VIEWS

WASHINGTON

A COLLECTION OF PHOTOGRAPHS
BY CHRIS JACOBSON

EMERALD POINT PRESS
an imprint of

Thunder Bay Press

ISBN 10: 0 9637816 2 6
ISBN 13: 978 0 9637816 2 8

Copyright © 2006
Thunder Bay Press, Holt, Michigan

Copyright © 2005
Emerald Point Press, Seattle, Washington
An imprint of Thunder Bay Press

Cover:
Sunset at First Beach, La Push, Washington

Printed in China

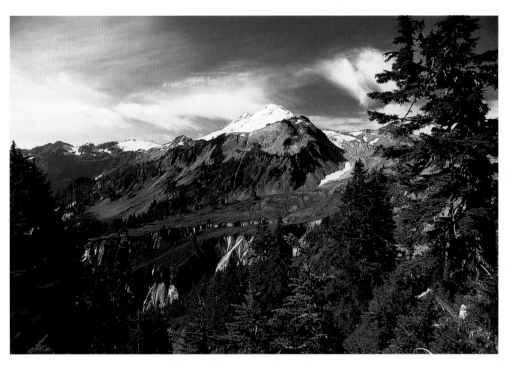

MOUNT BAKER FROM ARTIST POINT

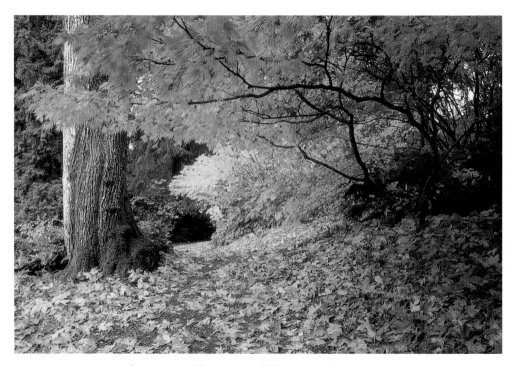

FALL COLORS, UNIVERSITY OF WASHINGTON ARBORETUM

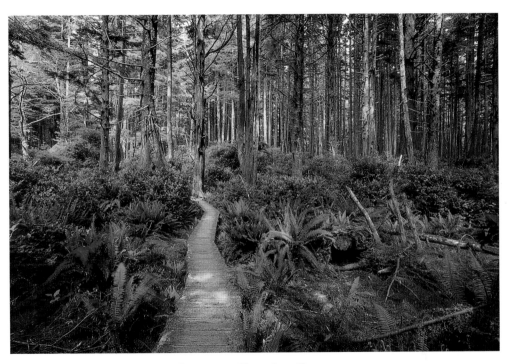

BOARDWALK TRAIL, LAKE OZETTE

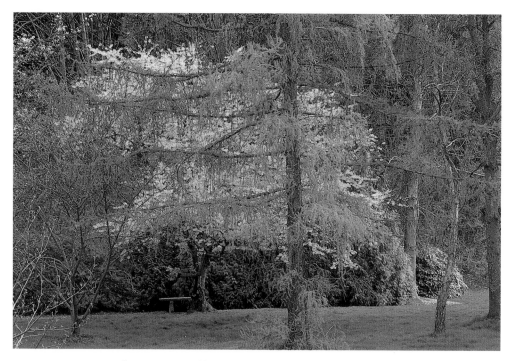

SPRING COLORS, UNIVERSITY OF WASHINGTON ARBORETUM

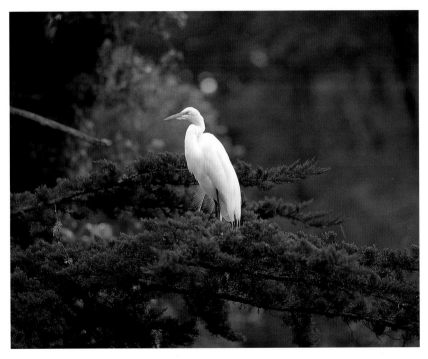

SNOWY EGRET

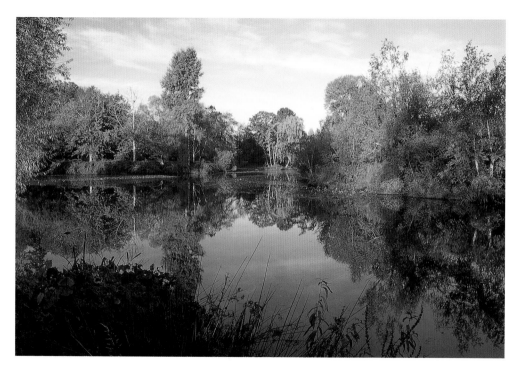

WETLANDS, UNIVERSITY OF WASHINGTON ARBORETUM

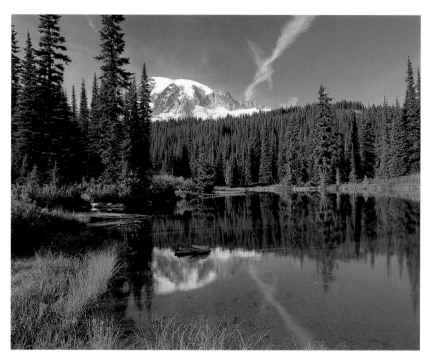

MOUNT RAINIER FROM UPPER REFLECTION LAKE

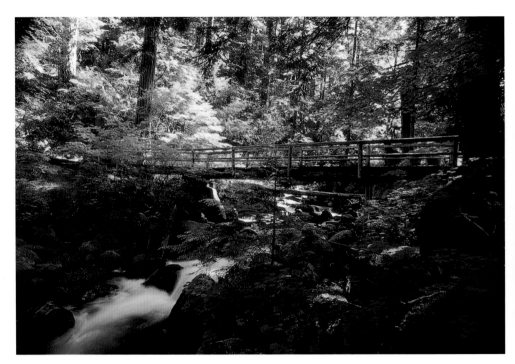

LAUGHINGWATER CREEK, OHANAPECOSH

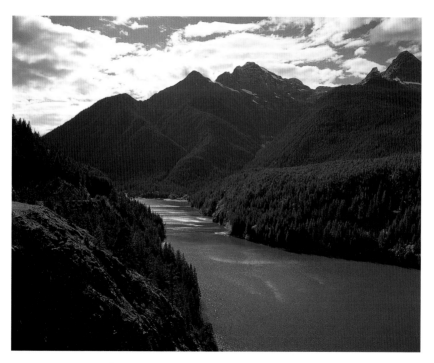

Ross Lake, North Cascades National Park

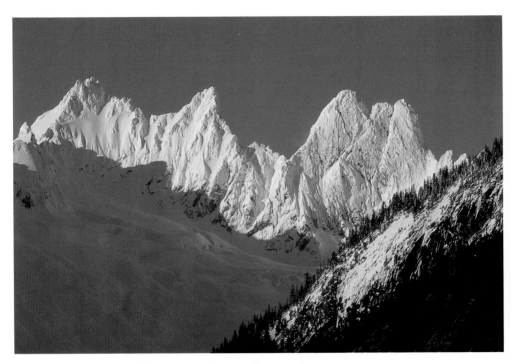

THE PINNACLES, NORTH CASCADES NATIONAL PARK

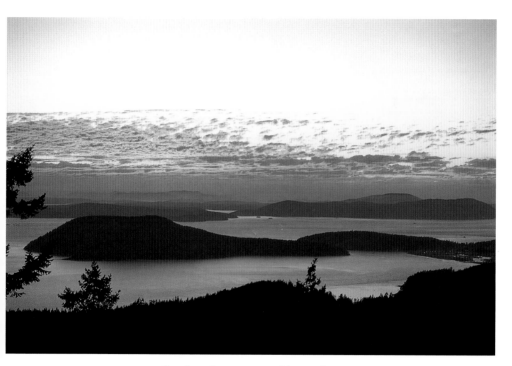

SAN JUAN ISLANDS FROM MOUNT ERIE

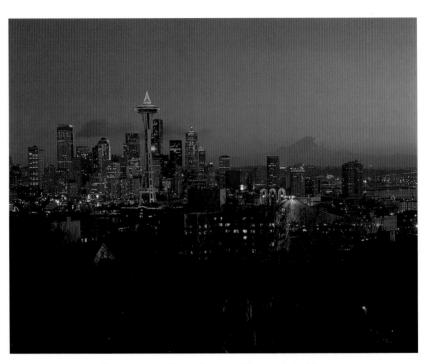

SEATTLE FROM KERRY PARK ON QUEEN ANNE HILL

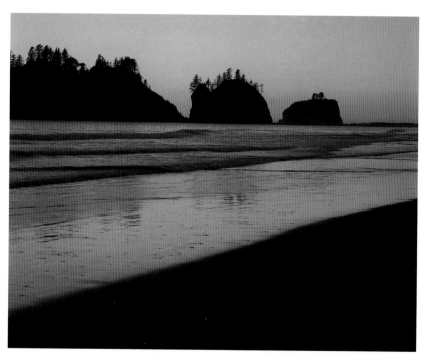

SEA STACKS AT FIRST BEACH, LA PUSH

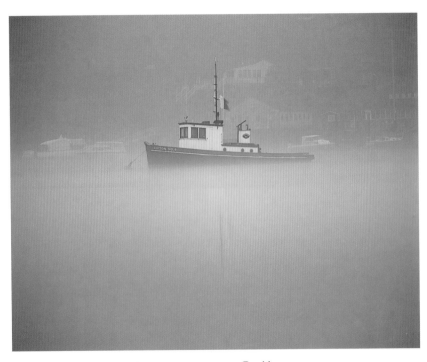

TUG BOAT IN THE MIST, GIG HARBOR

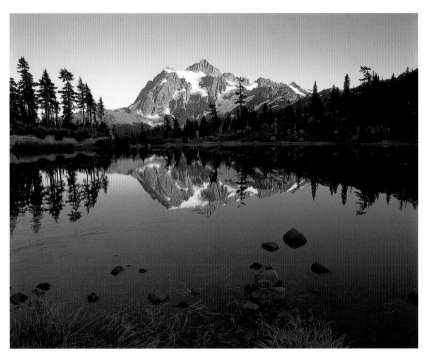

MOUNT SHUKSAN FROM PICTURE LAKE

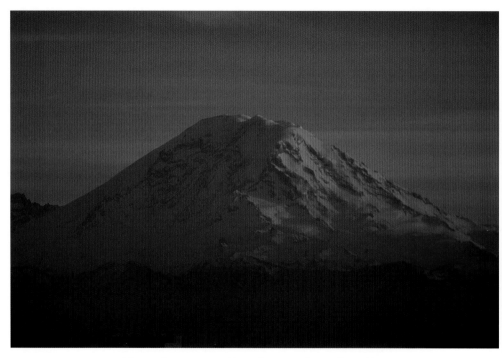

MOUNT RAINIER FROM KERRY PARK ON QUEEN ANNE HILL

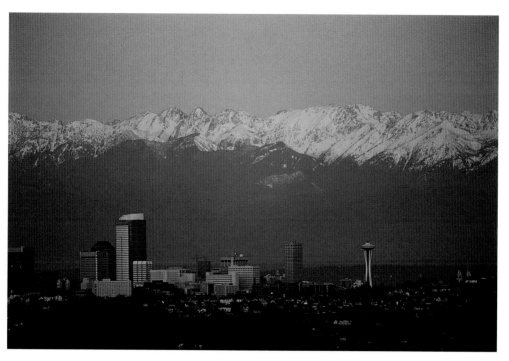

SEATTLE AND THE OLYMPICS FROM SOMMERSET HILL

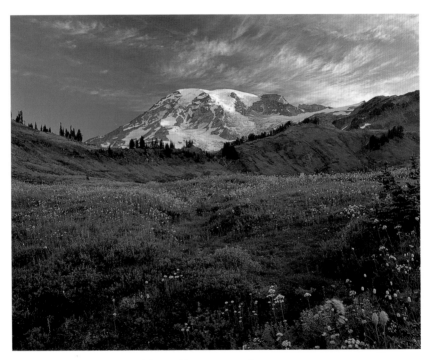

MOUNT RAINIER FROM PARADISE

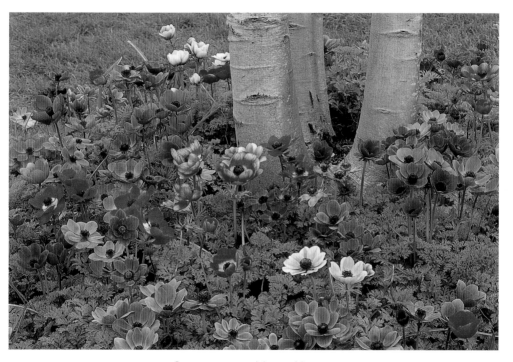

SPRING FLOWERS, MOUNT VERNON

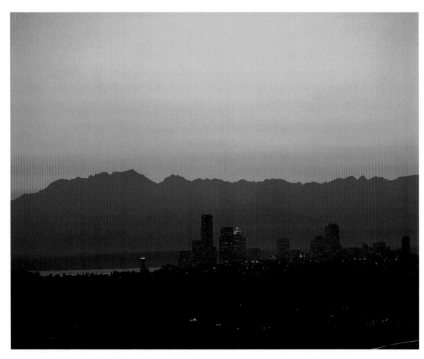

SEATTLE AND THE OLYMPICS FROM SOMMERSET HILL

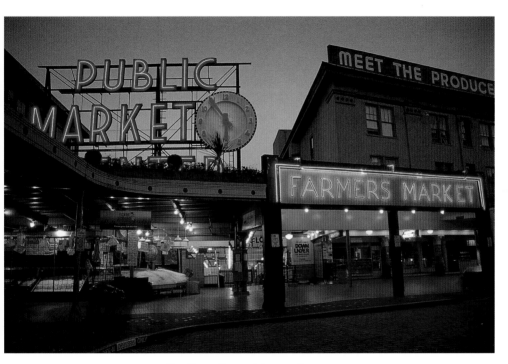

PIKE PLACE PUBLIC MARKET, SEATTLE

CAMELLIA, UNIVERSITY OF WASHINGTON ARBORETUM

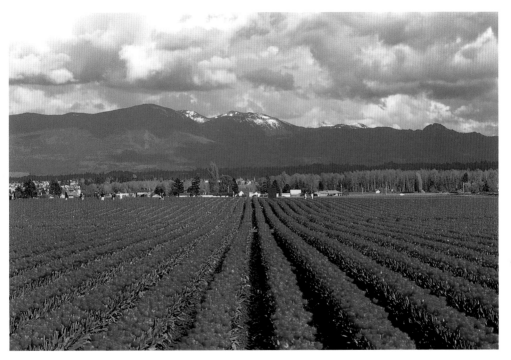

Tulip fields, Mount Vernon

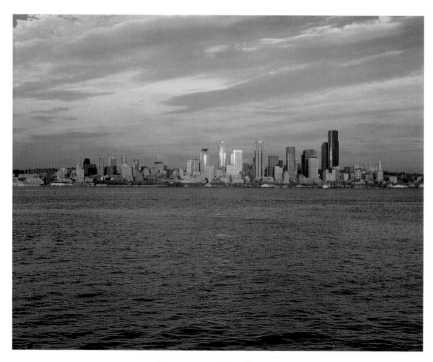

SEATTLE FROM ALKI BEACH

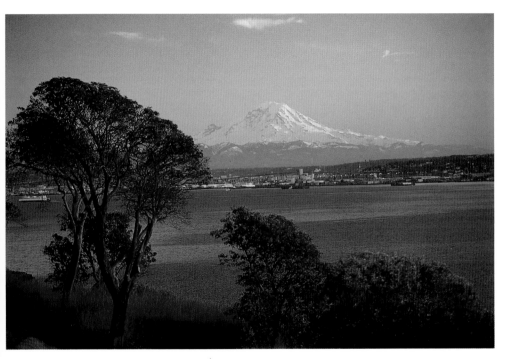

MOUNT RAINIER AND PUGET SOUND FROM MAGNOLIA PARK

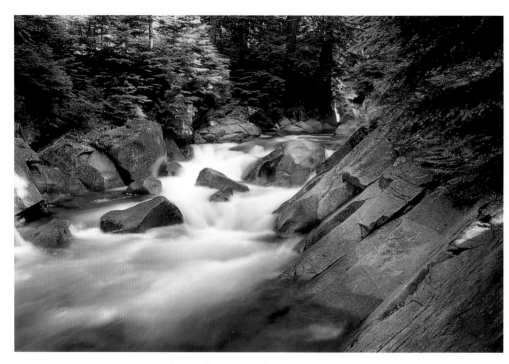

DENNY CREEK NEAR SNOQUALMIE PASS

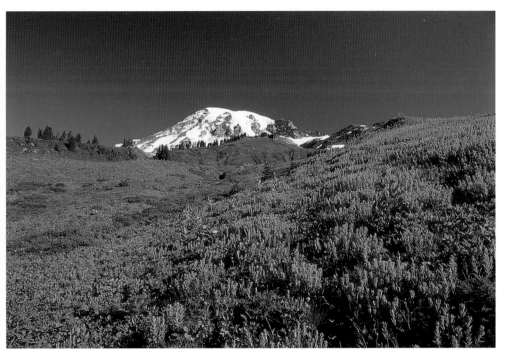

MOUNT RAINIER FROM PARADISE

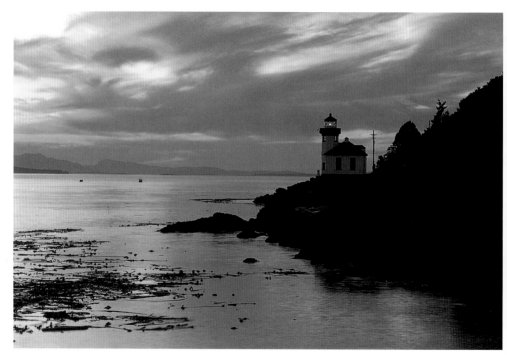

LIME KILN LIGHTHOUSE, SAN JUAN ISLAND

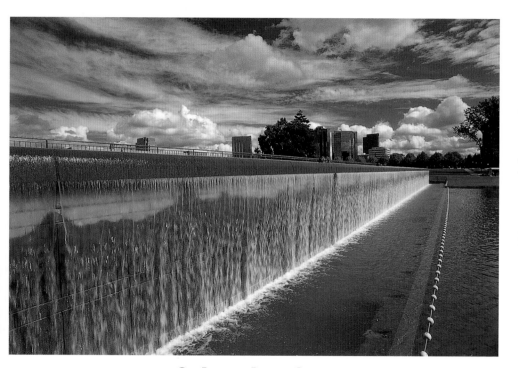

CITY PARK AND BELLEVUE SKYLINE

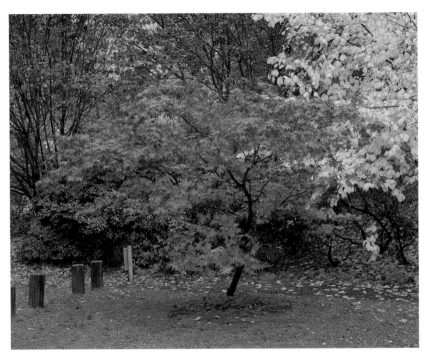

Fall colors, University of Washington Arboretum

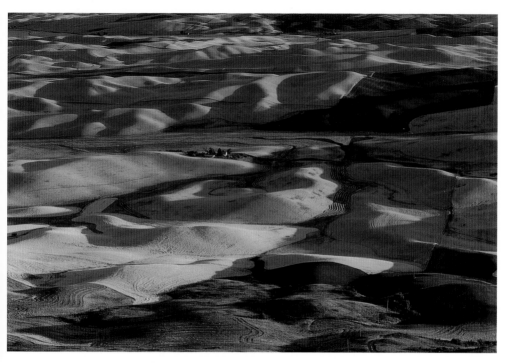

PALOUSE WHEAT FIELDS FROM STEPTOE BUTTE

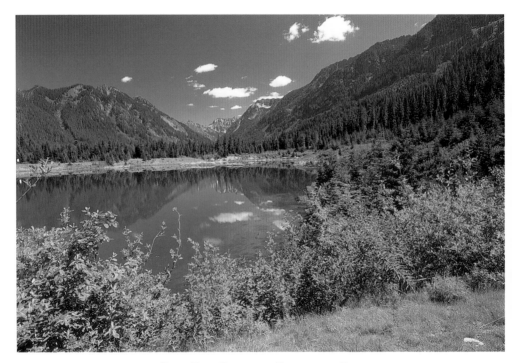

GOLD CREEK POND NEAR SNOQUALMIE PASS

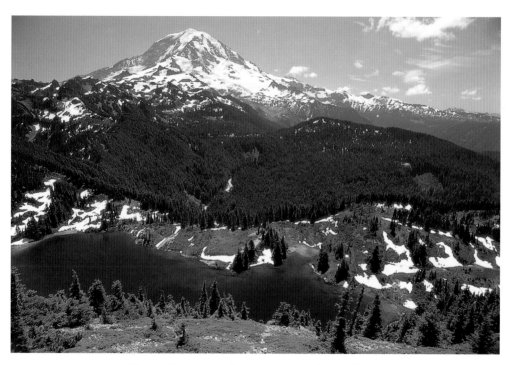

Mount Rainier and Eunice Lake from Tolmie Point

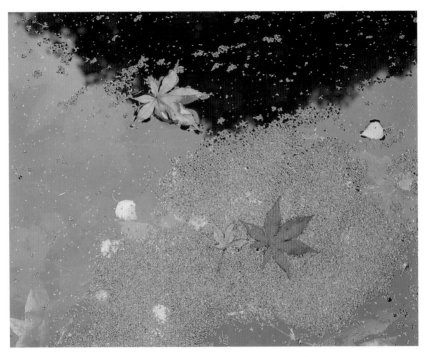

POND WITH LEAVES, UNIVERSITY OF WASHINGTON ARBORETUM

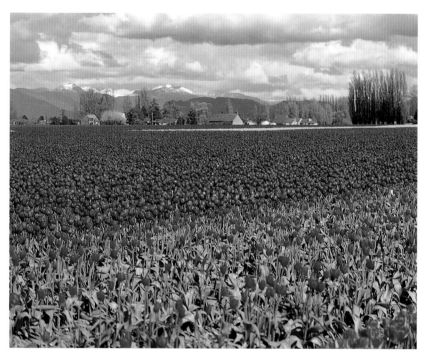

Tulip fields, Mount Vernon

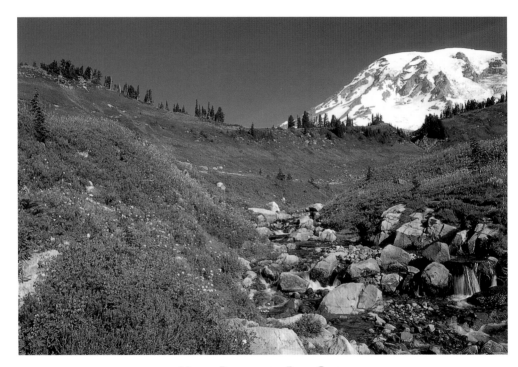

MOUNT RAINIER FROM EDITH CREEK

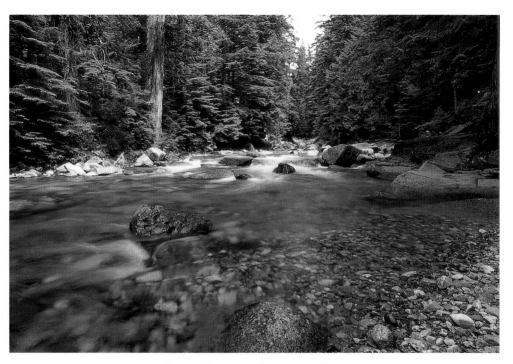

DENNY CREEK NEAR SNOQUALMIE PASS

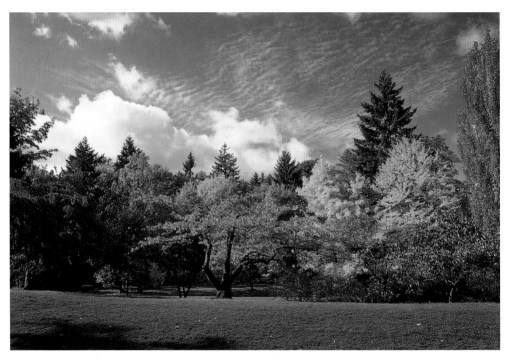

FALL COLORS, UNIVERSITY OF WASHINGTON ARBORETUM

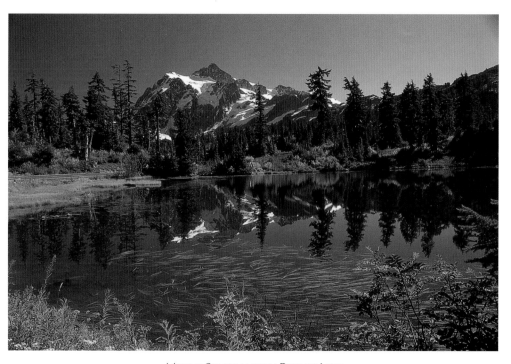

MOUNT SHUKSAN FROM PICTURE LAKE

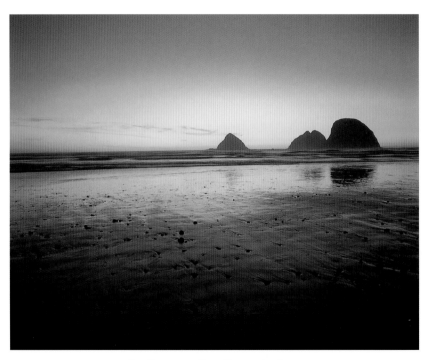

Sea Stacks at First Beach, La Push

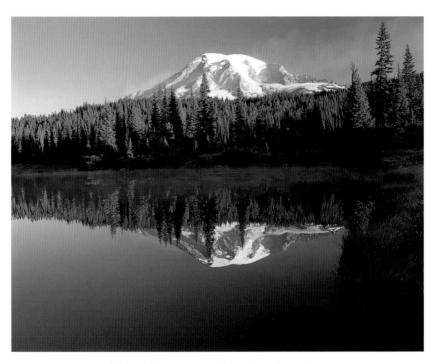

MOUNT RAINIER FROM UPPER REFLECTION LAKE

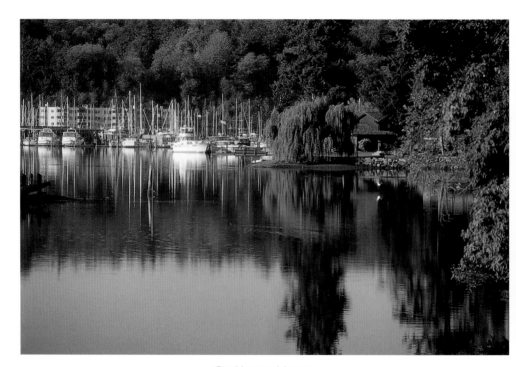

Gig Harbor Marina

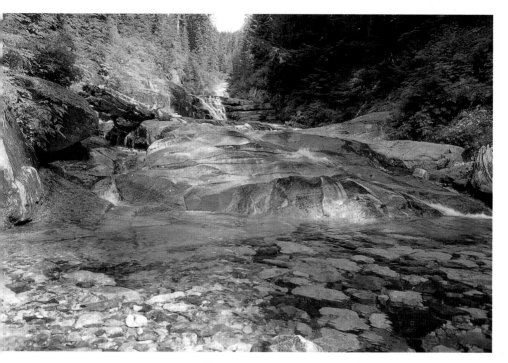

Bathing rocks at Denny Creek near Snoqualmie Pass

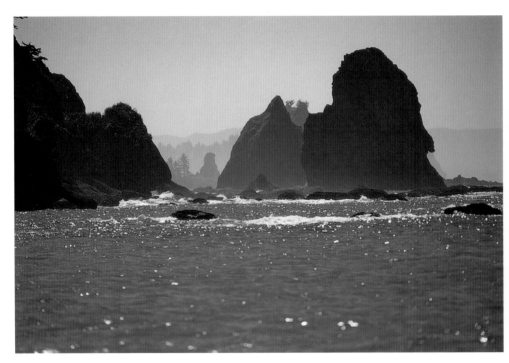

COASTLINE, OLYMPIC NATIONAL PARK

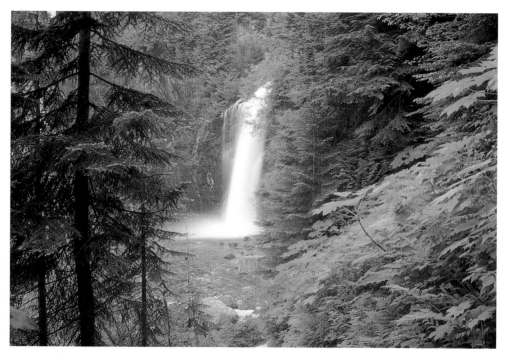

Franklin Falls near Snoqaulmie Pass

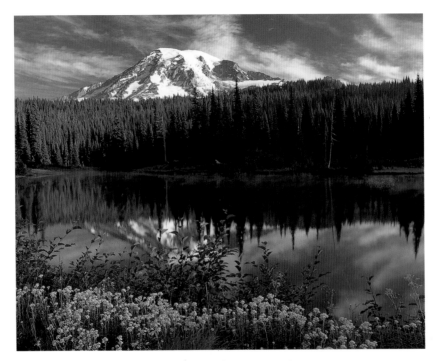

MOUNT RAINIER FROM REFLECTION LAKES